Dreaming of Flowers
By Rowan Blair Colver
An amalgam of images and poetry.

ISBN - 978-1480094055

An Indigo Poet Creation

indigopoet.co.uk

This book and its entire contents are subject to copyright
All rights reserved © 2012 Rowan Blair Colver, Indigo Poet Creations

Dreaming of Flowers
By Rowan Blair Calver

An amalgam of selected images and poetry
Lovingly dedicated to people everywhere

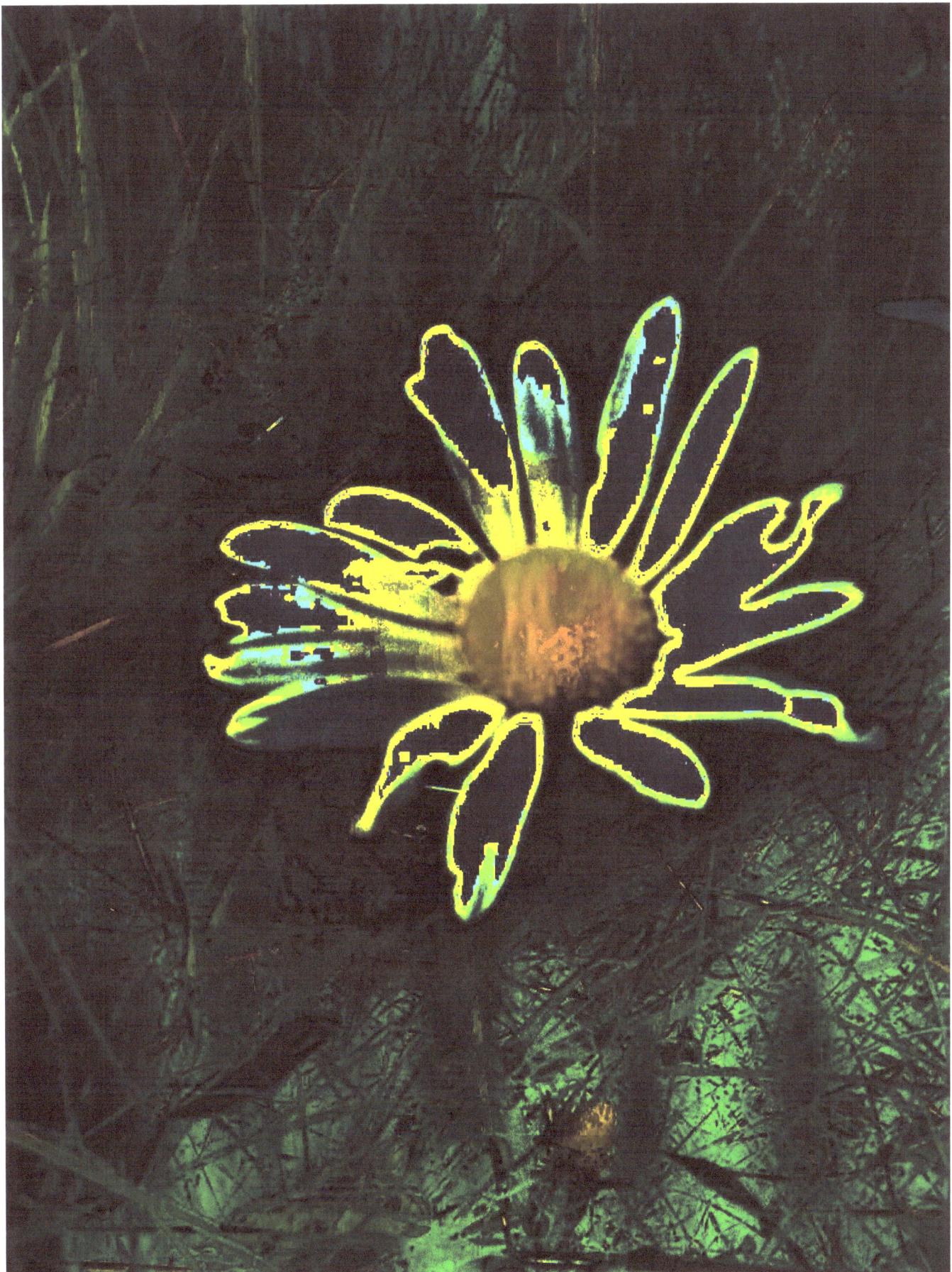

You have that kind of energy about you,
Thats brings inspiration to fly,
To jump from my window and reach into the sky,
Sometimes talking to you brings tears to my eyes,
Blessed am I,
Blessed am I.
My friendship in you,
Carries something brand new,
Tingles from sighs across the oceans of miles,
So I write down for you,
These humble lines,
To try and explain,
That you take away pain, bring blue sky to rain, remind me again,
That I am worthy of love from someone so lovely,
Even if only for a moment at a time.

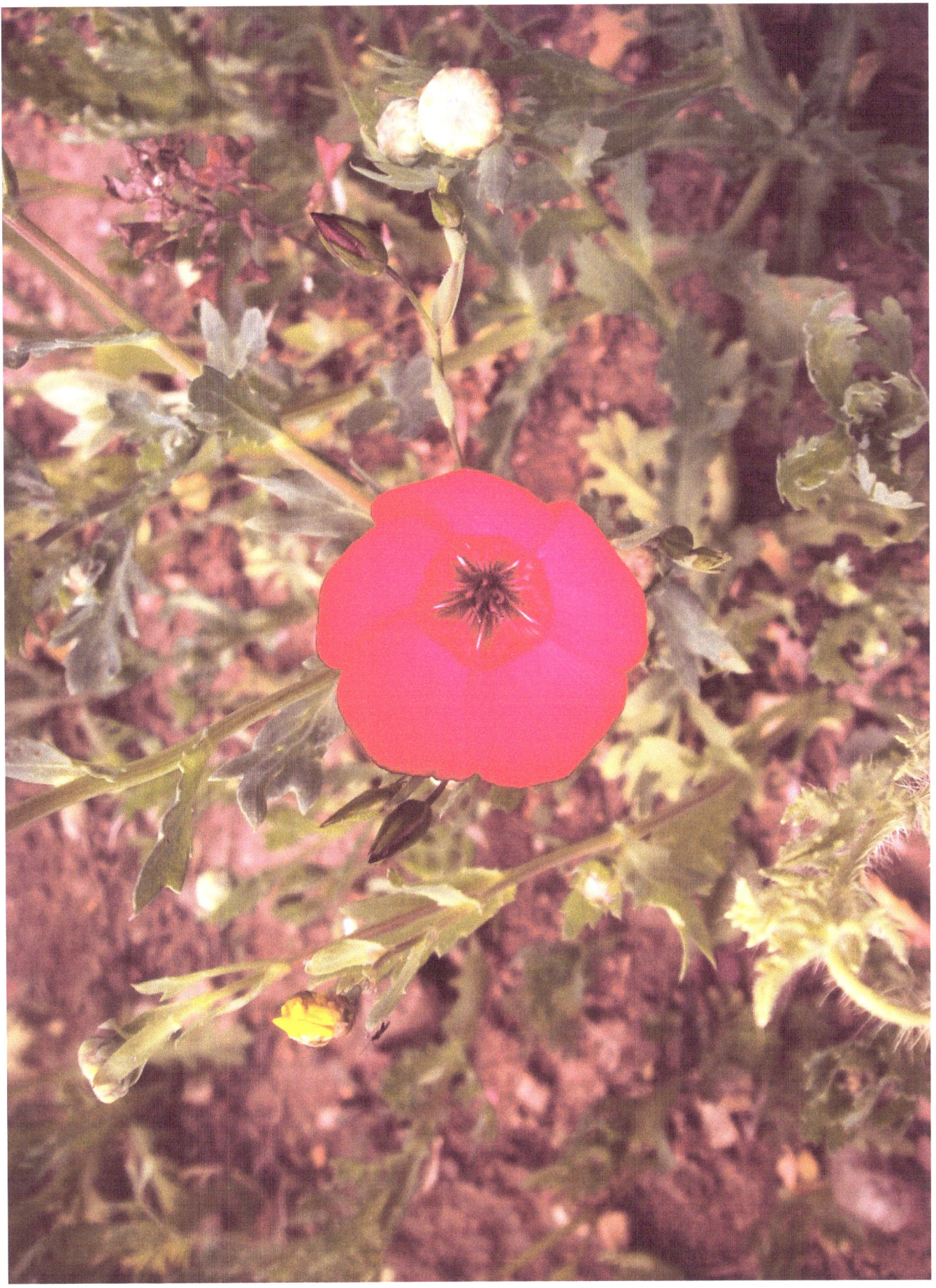

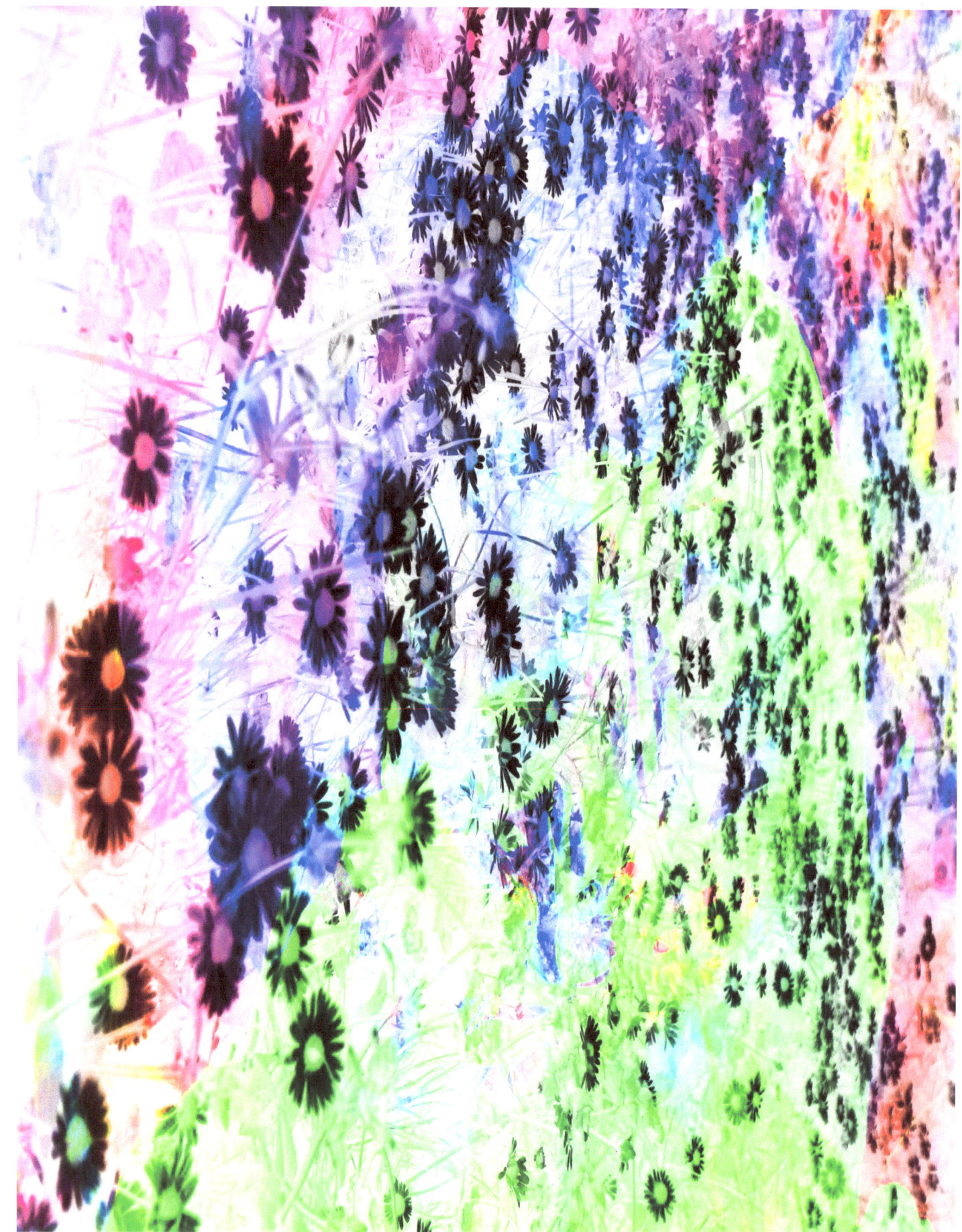

Change

With the brittling of the bracken leaf,
The yellow moon sings to dreamers beneath,
Bringing forward the deciduous remains,
Feathered shadow of silence reveals change.
No howling sentiment suffers hunger so,
Further than the spirits coiled in snow,
Yet drowned in thick invisible tides,
No-where dry for the dreadful divide.
Such swirling and churning of thought,
Brings the ghosts and feelings distort,
Swimming in viscous foam choking and blind,
Somewhere this spoil sings voices to find.

I Could Have Been

I could have been a star man,
Of the rainbow in your heaven's eye,
I could have been born of land,
Looking up at the cinnamon sky.

I could have been a being,
From a realm that understands this,
I could have been here seeing,
Just how complex this is.

I could have been an angel,
Unseen but with you all the time,
I could have been apparent,
But difficult to define.

I could have chosen the eternal,
Breathing light as nourishing me,
But I travelled down the tunnel,
To be part of your humanity.
I have faith that the nature,
Although now hidden from my heart,
Will bring love and nurture,
And my memory of light did not depart.

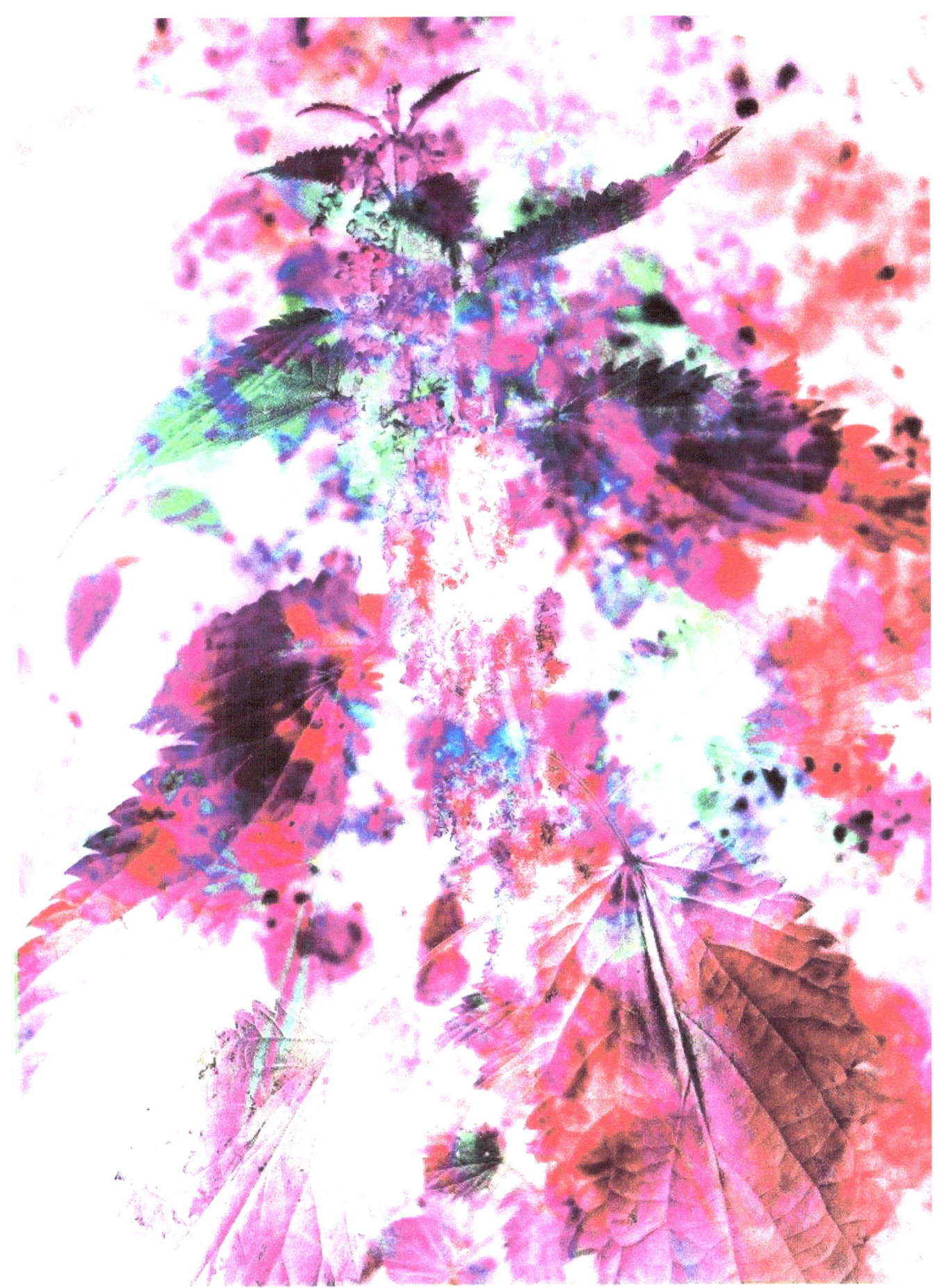

Dandelion Clock

With a licking intention, a gasp of air muses,
Caressing the pressure, warm and cool diffuses,
Stem, upright, firm with ample roots,
Vermillion fibrous tight, and in cushioned shoots,
Tiny filament seeds, a forest on a semi-globe.
Each miniscule node, a potential, with needs,
And it allures. Entices the air,
As it forms itself around in pockets,
Capacitating pulse in time, in frolics,
Not to mention bubbles of desire,
If it had eyes,
It gave those to us,
But for it, to brush, to sweep, provides.
The snap of tension builds and sounds,
And the howl salivates in gust.
One o'clock, two o'clock, time must,
Fly, like dandelion seeds,
Into the wind.

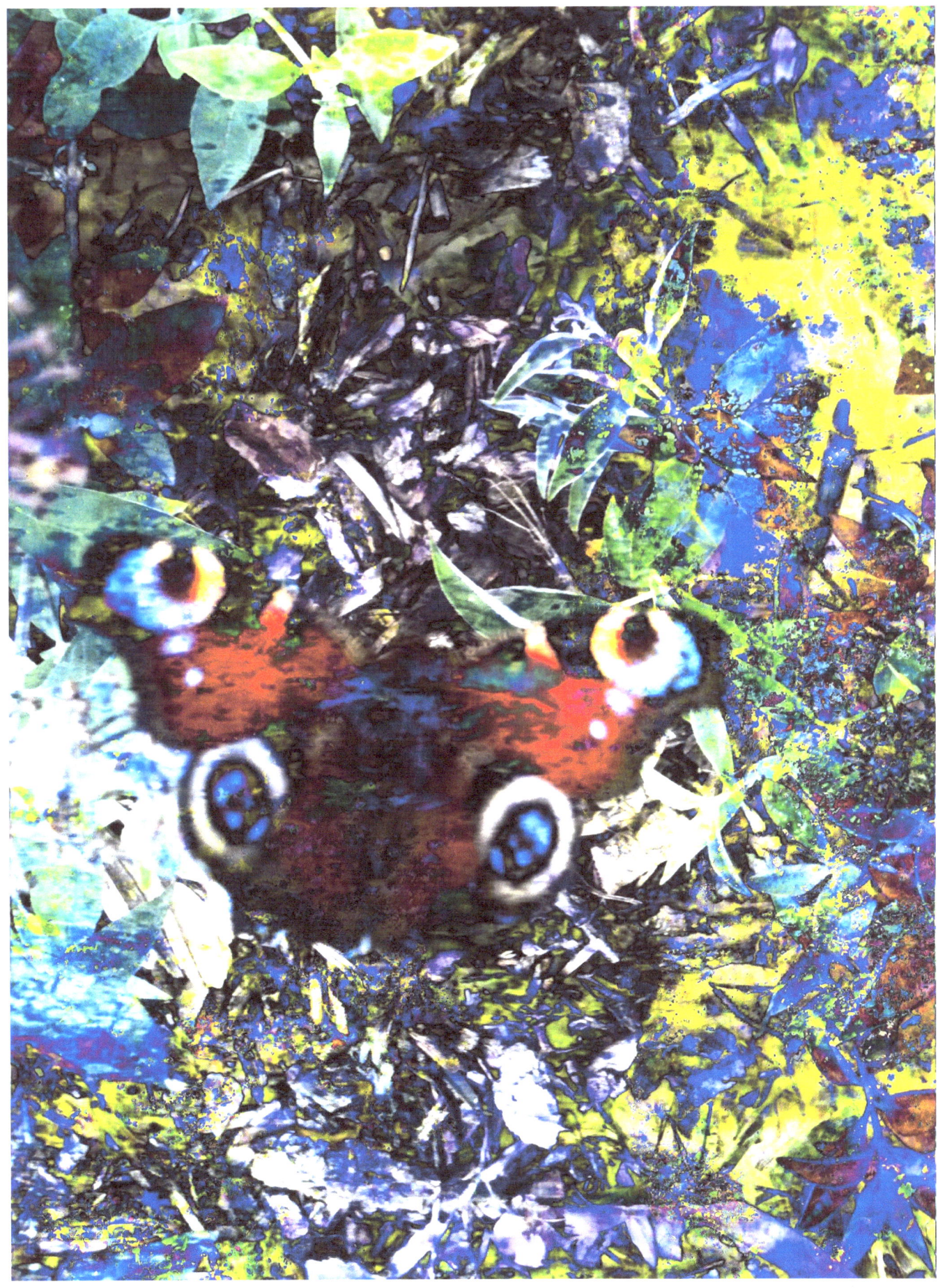

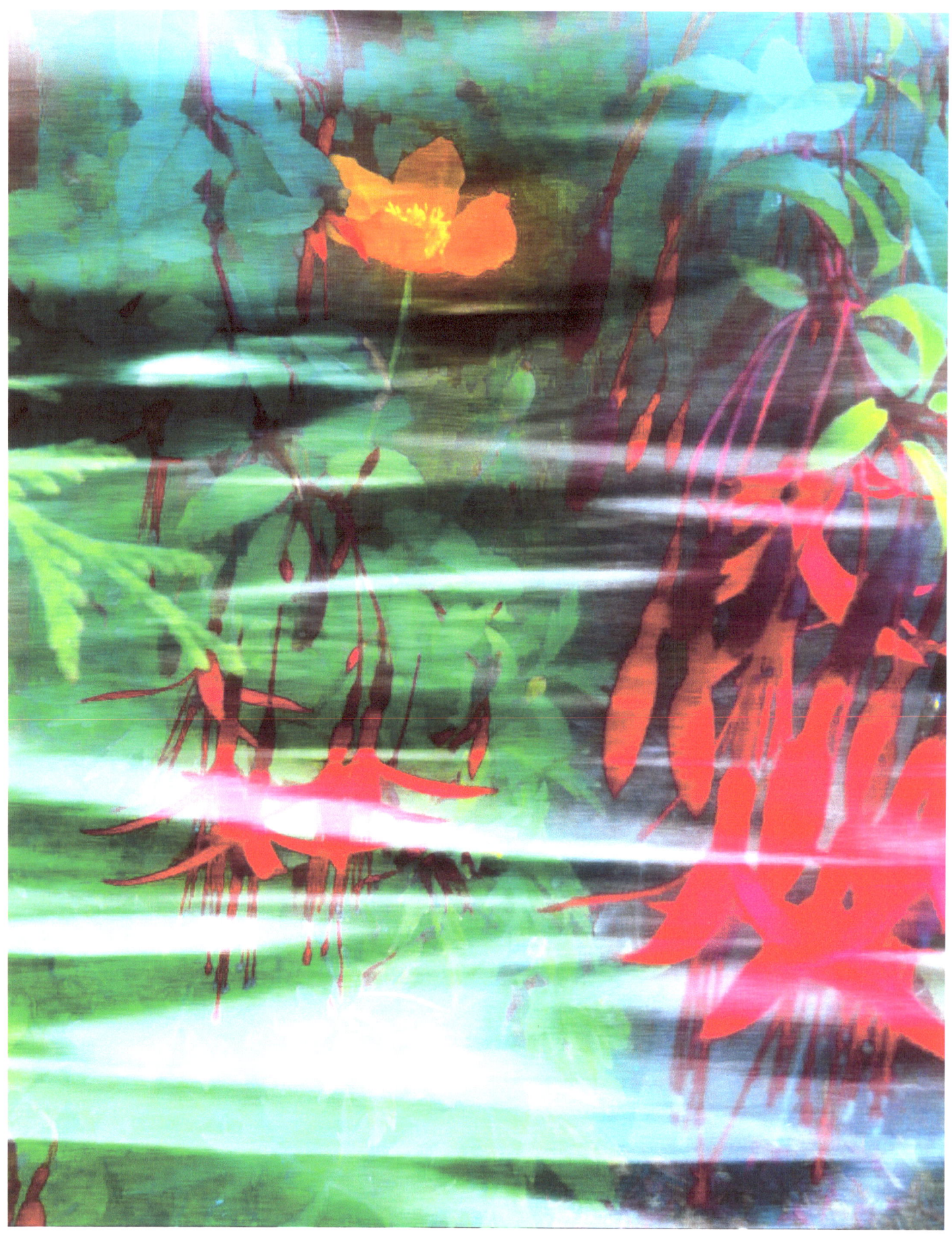

Faith

As a vortex of unanswered twists through me,
In its flurry of worry and insecure conviction,
How did this holy water become snow?
As children play with gloves, hats and dreams.
Elasticated reason of fortitude loose,
The hanged man's smile upon the song,
Whichever forest swells this eve'n weeps,
With me, the stream and the ever growing sea.
With joy, mind your thoughts, truest pagan spell,
Revealing our hallows with the awkward knell,
At twilight time when owls and foxes play,
With their universe as we send ours to sleep.
To reveal, all wellness within deepest wishing,
Coins and silver things twinkle like faith,
When the stars emerge they join with the chorus,
Bringing the coiling energy upward, in honour.

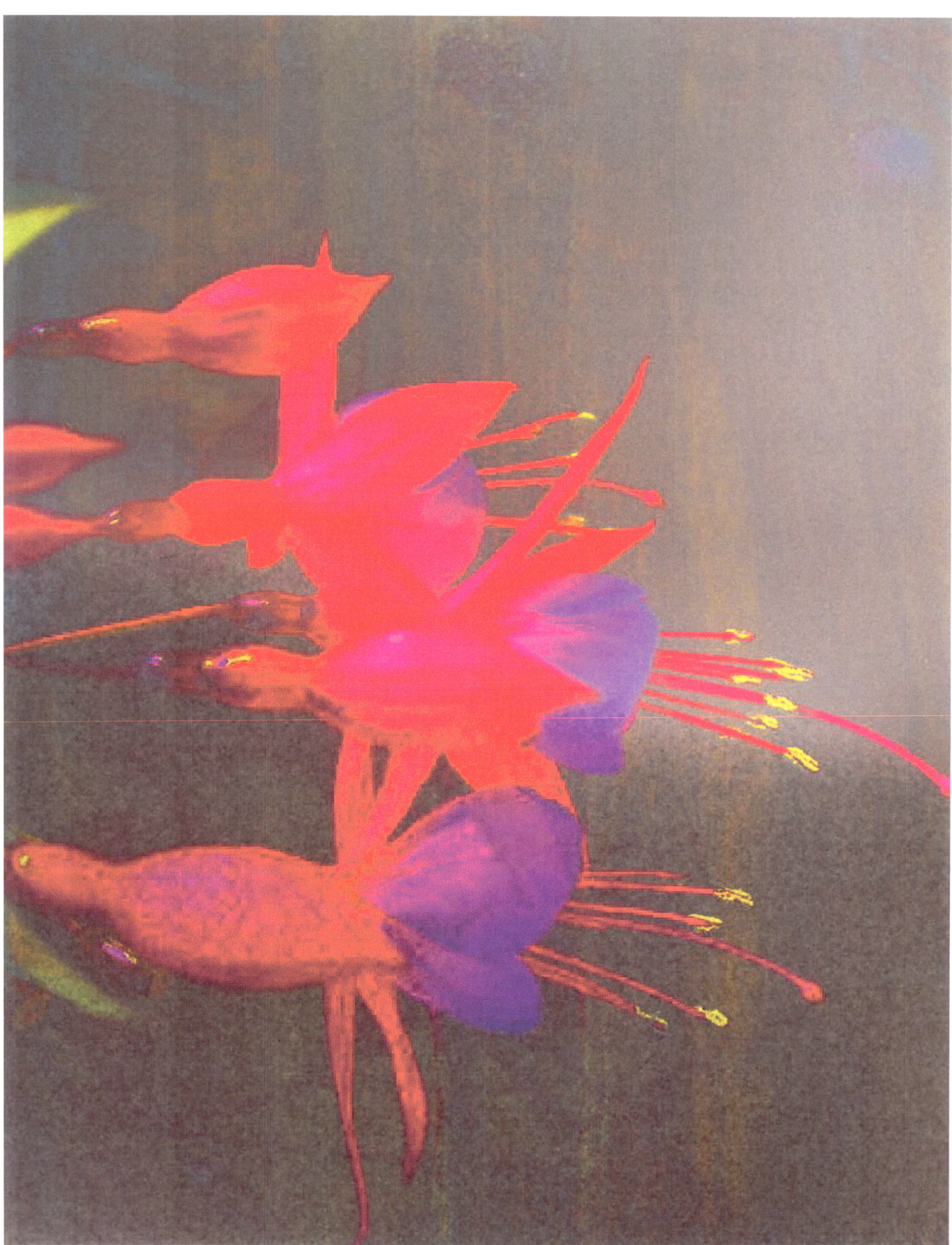

I Dreamed

Amidst confusion and faith,
Among the dreariest of days,
I dreamed.
I gave thanks for the things
That are yet to be.
With a crystal of love,
Fadden, connected, through and above,
I projected my dues.
There was a path in the forest,
It forked and I chose you.
One way was fear, protective and cold,
The other was sunshine, alive and involved.
I see around us thorns that still grab,
And bruises from stumbles,
When elbow hit slab.
Superficial.
The forest we walk is old and wise,
And with our eyes reminds us of truth.
Sweet angel, my walls, my roof.
Where can we hide,
When the storm clouds strike,
Our arms and our hearts,
Saved for each other and art,
A forest path so long, wide,
And laden with wild strawberries.

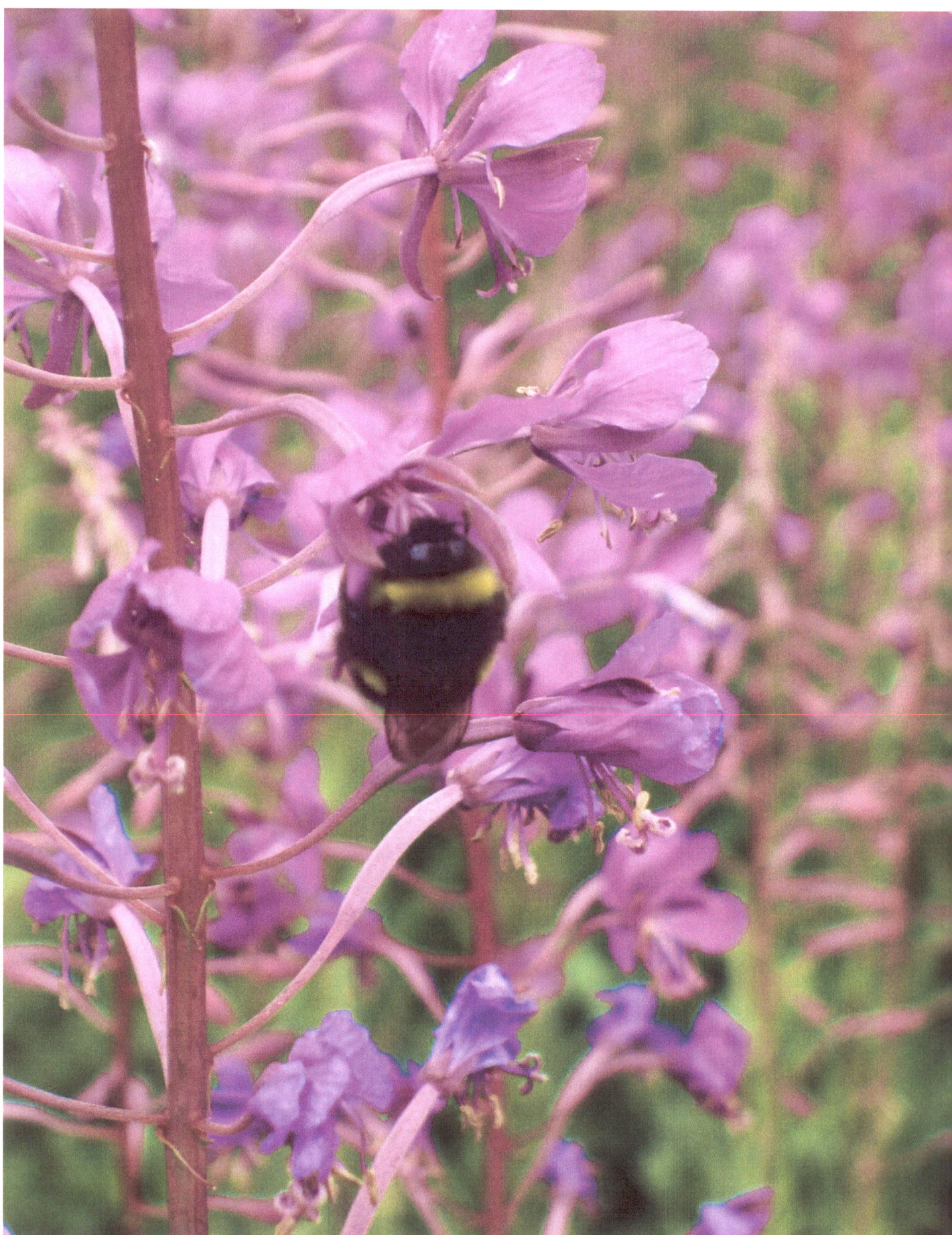

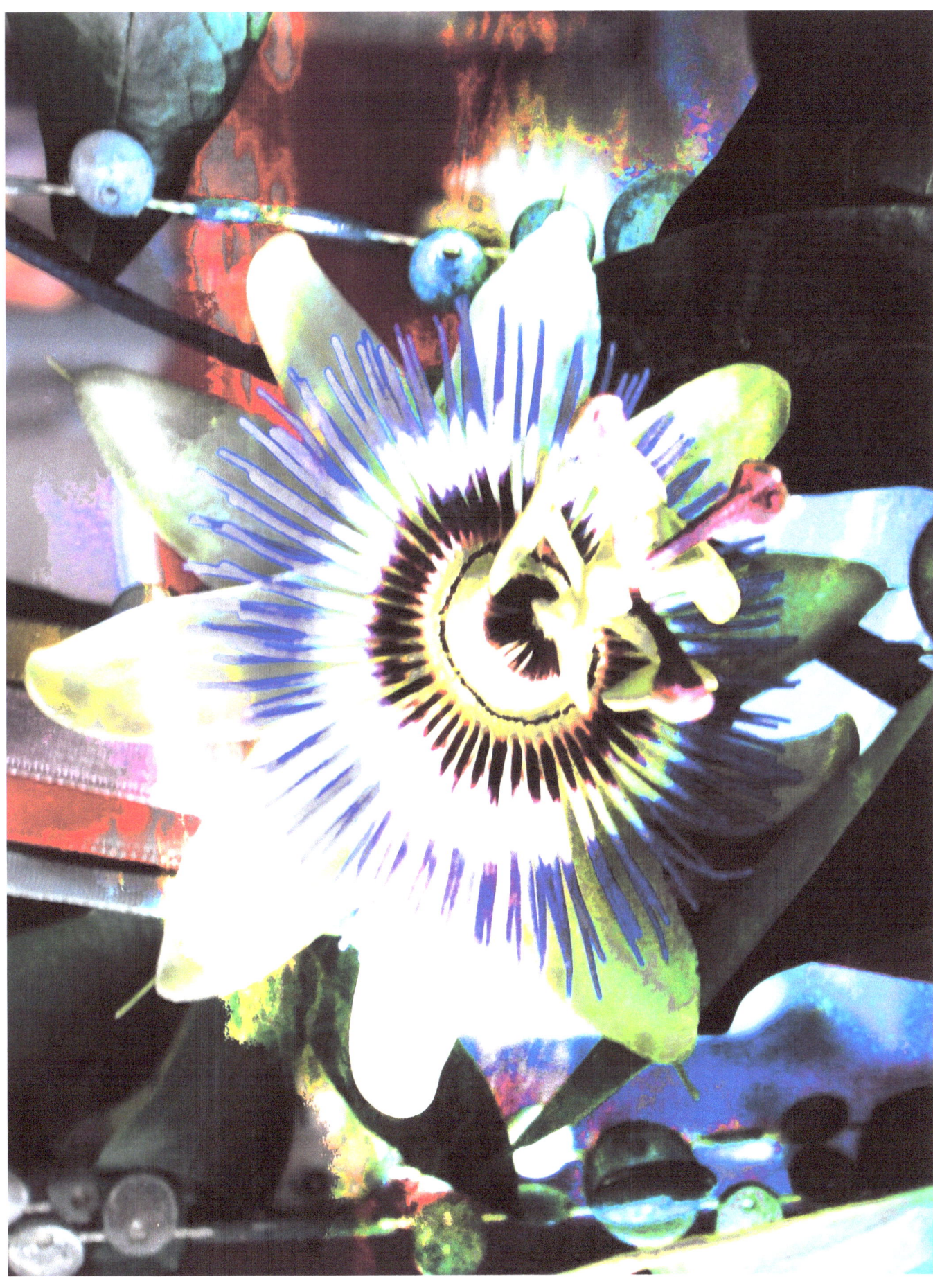

The Spark of Life

As an elusive spark flickers somewhere else,
It beckons me toward our hurricane trance,
Reliving a moment within perfect soliloquy,
Yet inviting the ears of our dancing galaxy.
Focus thrice matters silver and soul,
Living like Christ, living like Job,
Living like kings, frittering gold.
Speaking in riddles or writing in tongues,
Feverish spinney of tranquillity twirl,
Petal face of memory form and curl,
Onto my own, in flower's kissing aroma,
Then gone like the shimmering silver of minnows in the stream.

Invitation

There is a little place I know,
Where sometimes I like to go,
There I plant my seeds,
Of flowers and trees,
And wishes from the heart.
Maybe if you walk with me,
Hand in hand possibly,
Or simply side by side,
The smiles will not hide,
As the birdsong frames the day.
As you kneel in the grasses tall,
'mongst bracken shoots and petal fall,
Such colours greet thee there,
A blossom for your hair,
I planted the year before.

As it settles by your eyes,
Pinned to a grip on the side,
It opens with a rainbow bright,
Each digit a colour of light,
That kisses you seven times.
So look up and stand with me,
The sun and sky so heavenly,
A magic of your faithful flow,
Path towards you already know,
A secret in pen upon the drawer.
Waxy spell casting 'neath red,
Borrowed tears from a sleepy head,
Don't speak nor wish for this,
However the moment chooses bliss,
It is already done.

Hope
I named thee, more than once,
But today I name thee again.
You, my eternal friend,
Love, bringer of peace,
Are inspiration incarnate.
True form or not,
True void or not,
This brings forth majesty,
Brings forth blossoming of the mind,
Sheds light and connection between dream
Illusion, and sensation.
Within you.
When I reached out to nothing in faith,
I found you.
When I asked the sky for a refuge,
You arrived.
I put my bitter candle out,
And lit the wick on pink,
With aromas of ash and request.
Waxing eye portray growth,
Upon energies found within mine.
You came.
With open arms and praise.
I remembered who I came to be,
On that moment of conception.
I remembered what I chose to feel,
When the angel kissed my cheek.
You, blessed being of my wish,
To carry my joy from its nest,
Into wider air.

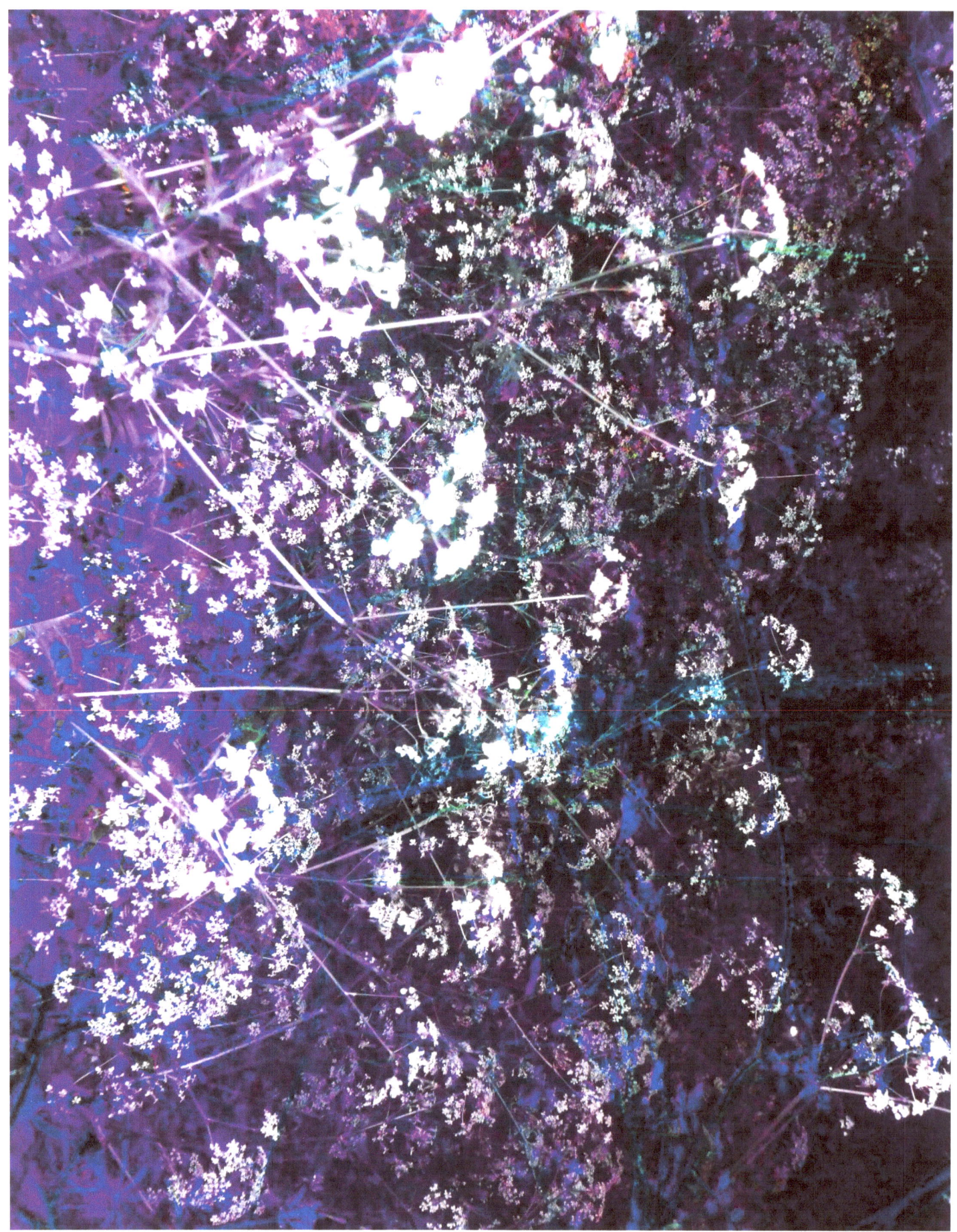

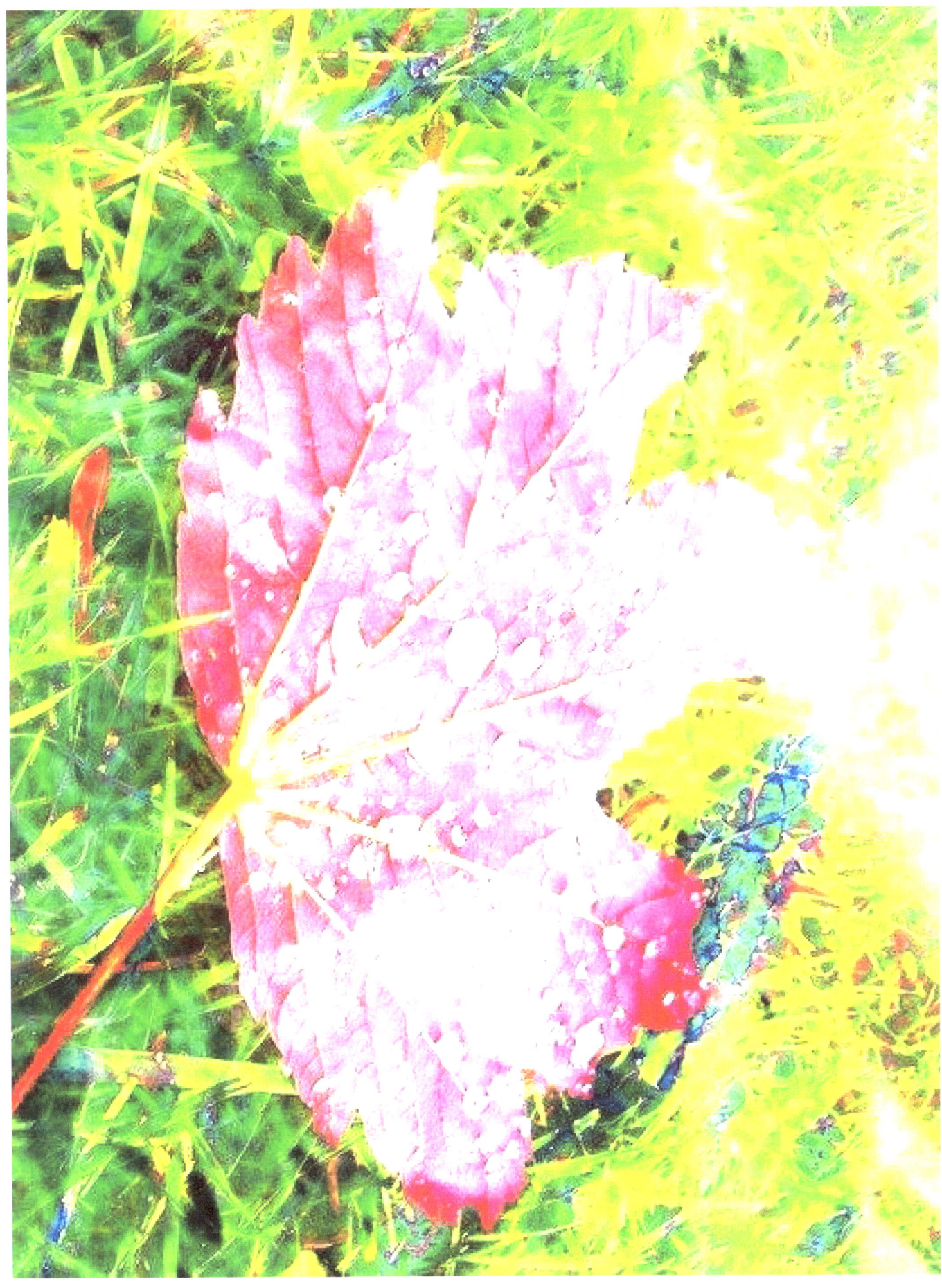

Labour

Growing fruits of mental labour,
Becoming manifest outside.
Planting seeds for my own favour,
Nature knows how hard I tried.
Sweeping streets of inner peace,
Burning bits of forgotten things,
Dreariness between the sheets,
Becomes like petal and wings.
Colours within the mind are such,
That reinvent their place in hue,
They never seem to say very much,
But now they remind me of you.

Nameless

Here in without the naming of such things,
We shall be enthralled by the voiding space,
Holding stars like a cyclone holding sand,
In the palm of each of your hands is this.

Cast aside are the drowning weights of you,
The insight of beauty behind the eyes,
Of face albeit spread across land and race,
The soul of a heart is the shine in the dark.

Form a word from a place of inner most joy,
Name yourself this at every single turn,
Feel the opalescence of the near visible self,
An ocean of integrity we walk above the waves.

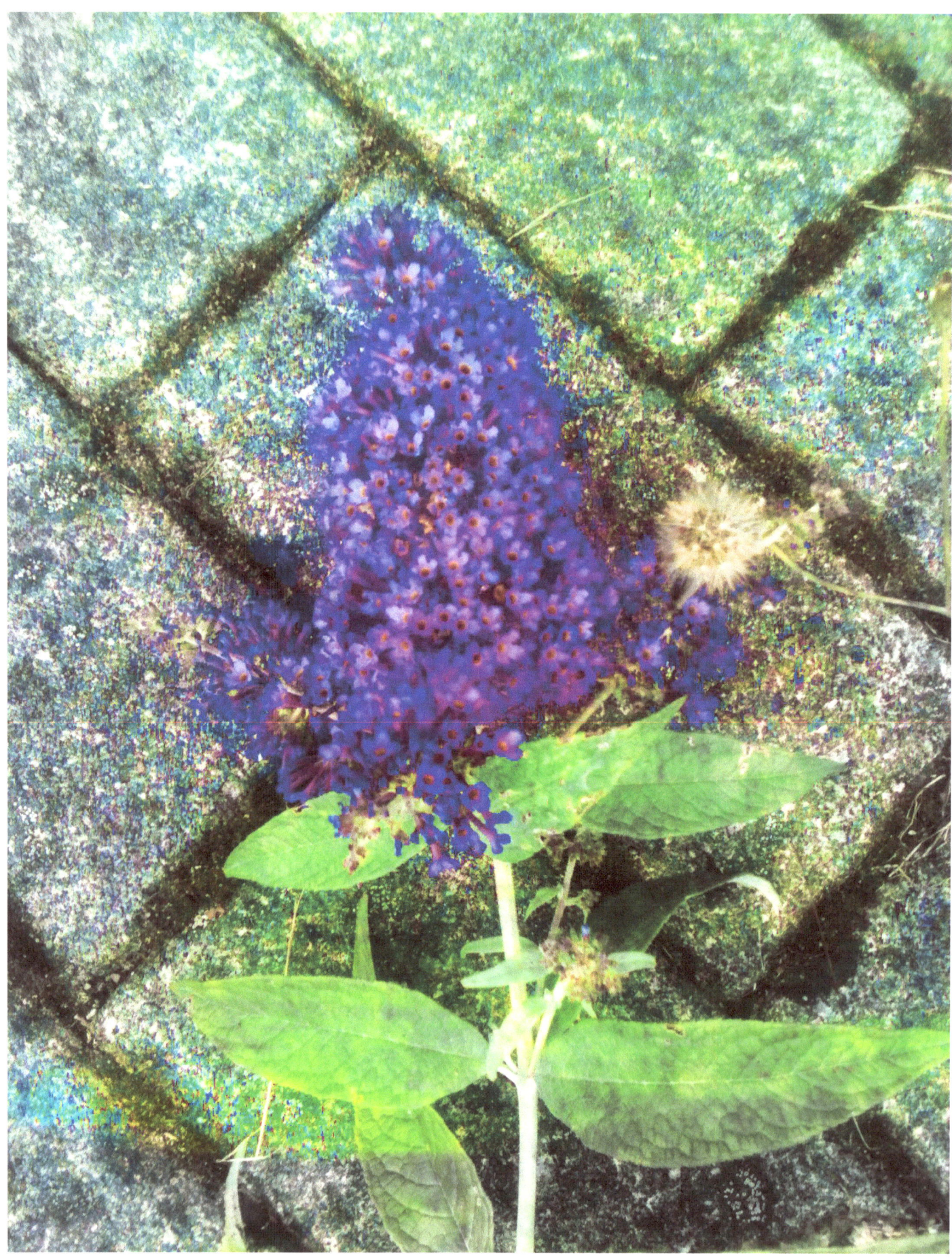

One Vision

Forward in one with a vision shared by heaven,
Threads are now spun that hold us towards forever,
Golden with light from a galaxy yet unborn,
Sung with a lullaby to awaken this beautiful morn.
Traces of the waters flow upon the weary shore,
Freshest rain and rivers know how long this drought is for,
Beacon of a moment entwined with something bright,
Sudden something forming with a twist of long due light.
So spiral sunny sky curves into translucent corners,
Opaque and forever high a symbol of the chorus,
Winged voices eternal sing in scripture from the heart,
Reminding the stars within the song shall never depart.
Somewhere deep inside a mind can be found a glimmering wish,
Something you can only find when feeling more than this,
A single spark of knowing breeds a candle then a flame,
Illuminates our inner needs and gives our soul a name.

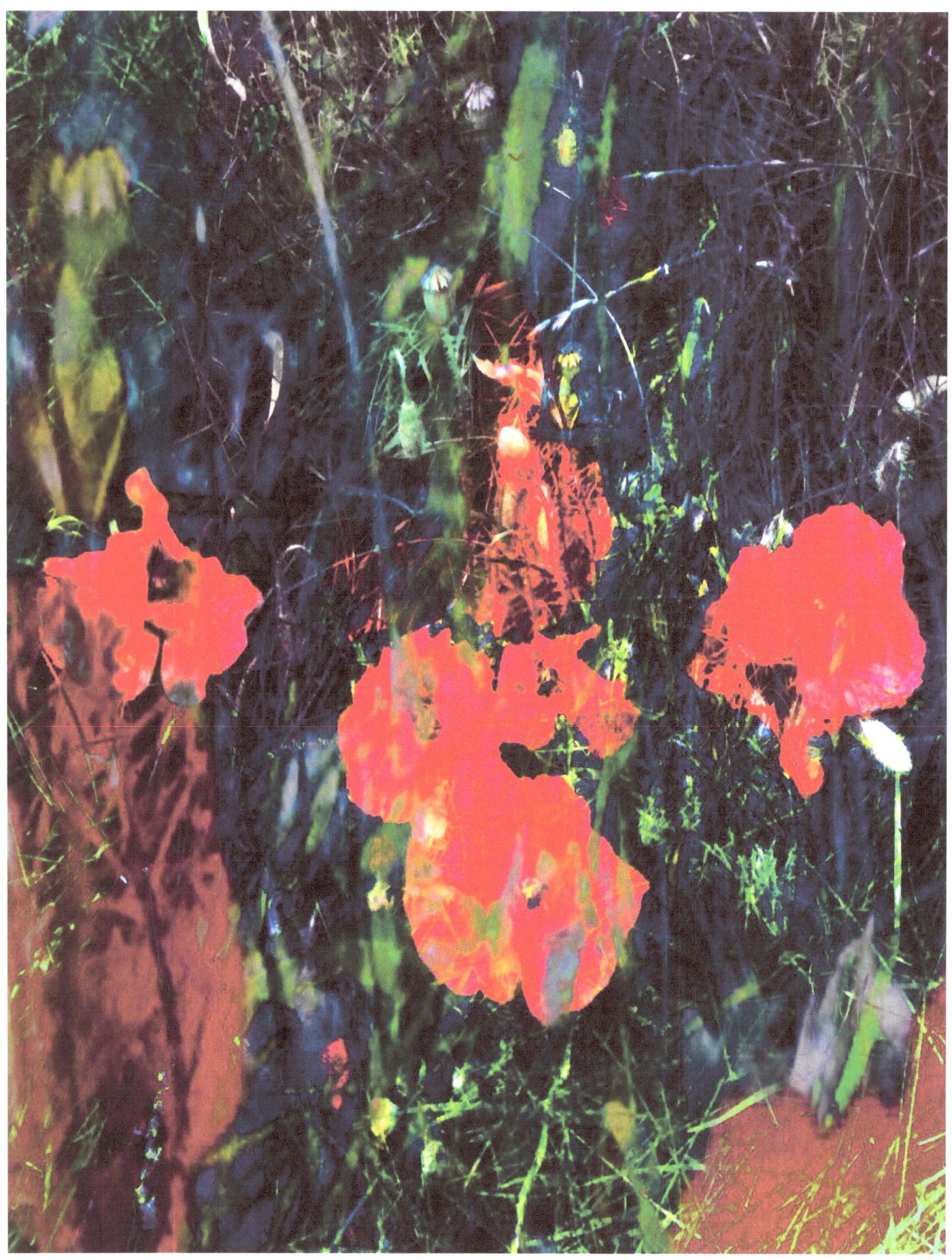

Does fruit bear from darkness alone?
Must faith be blind?
To start, listen to your heart,
Like the seed, you were given what you need,
Inside.
Do what you know is right,
Reach up towards the light,
Where your very matter says it will be.
Reach down with roots entwined,
Forming an anchor in the very divine,
That placed you, sewed the seed.
Before long an emergency of dream,
The leaves find their way to the sky,
So long ago it seems,
The seed was humble, bare and dry.
Remaining fragile yet growing in strength,
Ever growing roots for ever needing quench,
And blossoms will grow that attract folk,
And a bounty of admirers that stand and stare.
So when the time comes,
And fruit ripens,
There are many who are happy to share.
Does fruit bear from darkness alone?
Must faith be blind?
To start, listen to your heart,
Like the seed, you were given what you need,
Inside.

The Dance

Lend me a moment,
Place your faith in my pause,
Lost in the flow,
I project with harmonious cause.
A line in the glow,
Sweet melodies the start,
A hidden platinum,
Creator of beautiful hearts.
Grant me a dreaming home,
An illusory inner void,
Wish me a breath of life,
See the deception destroyed.
Universal life of patterns in petal,
The rose grows in time,
Air to Earth as Wood to Metal,
The dance is a sensual fire.

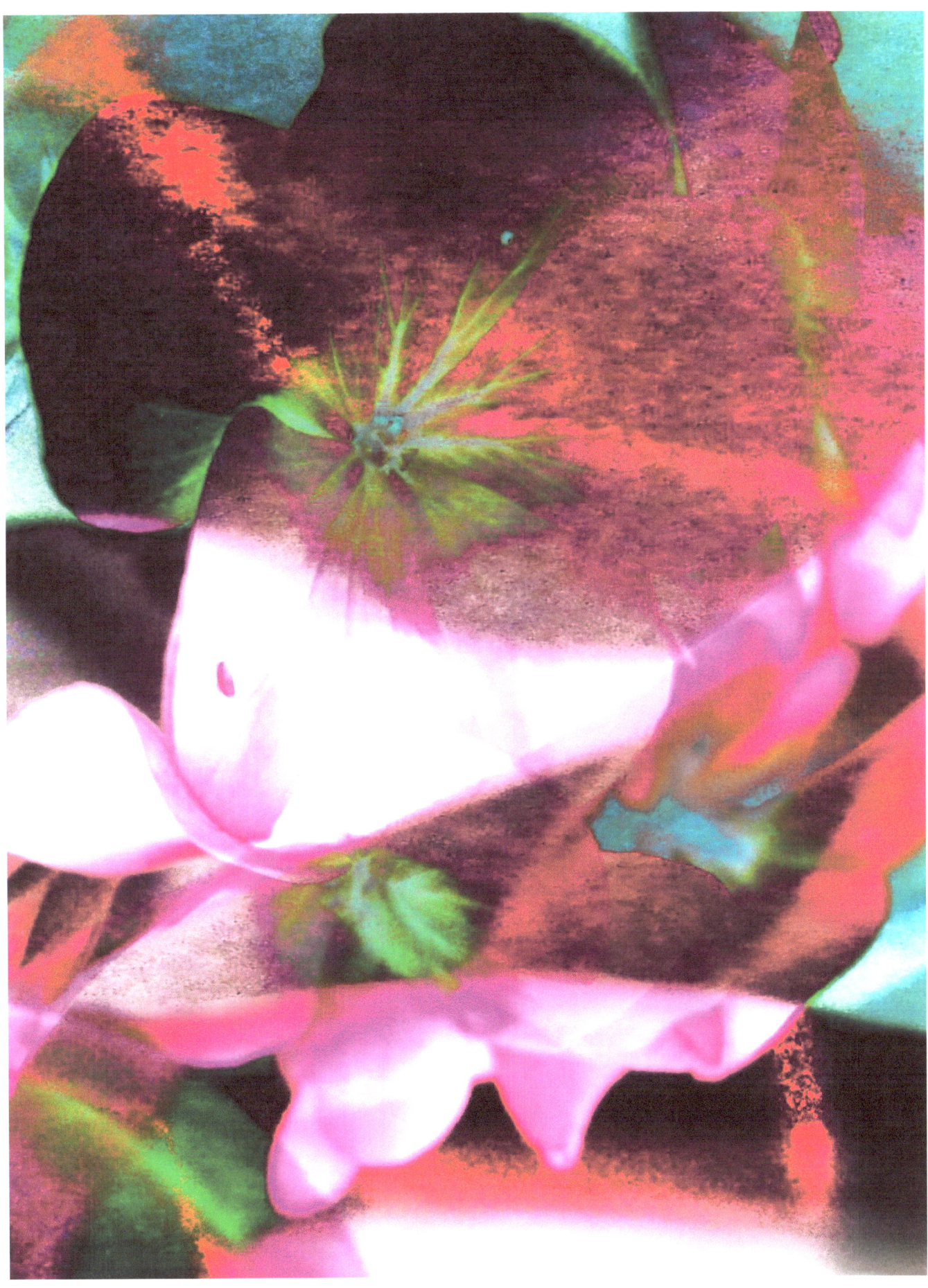

Yesterday's Summer

Hello sky from yesterday's summer,
Goodnight stars, see you soon my friends.
Yellow flower pictured firmly in mindful eyes,
Calling dew spills over you, reborn within dream.

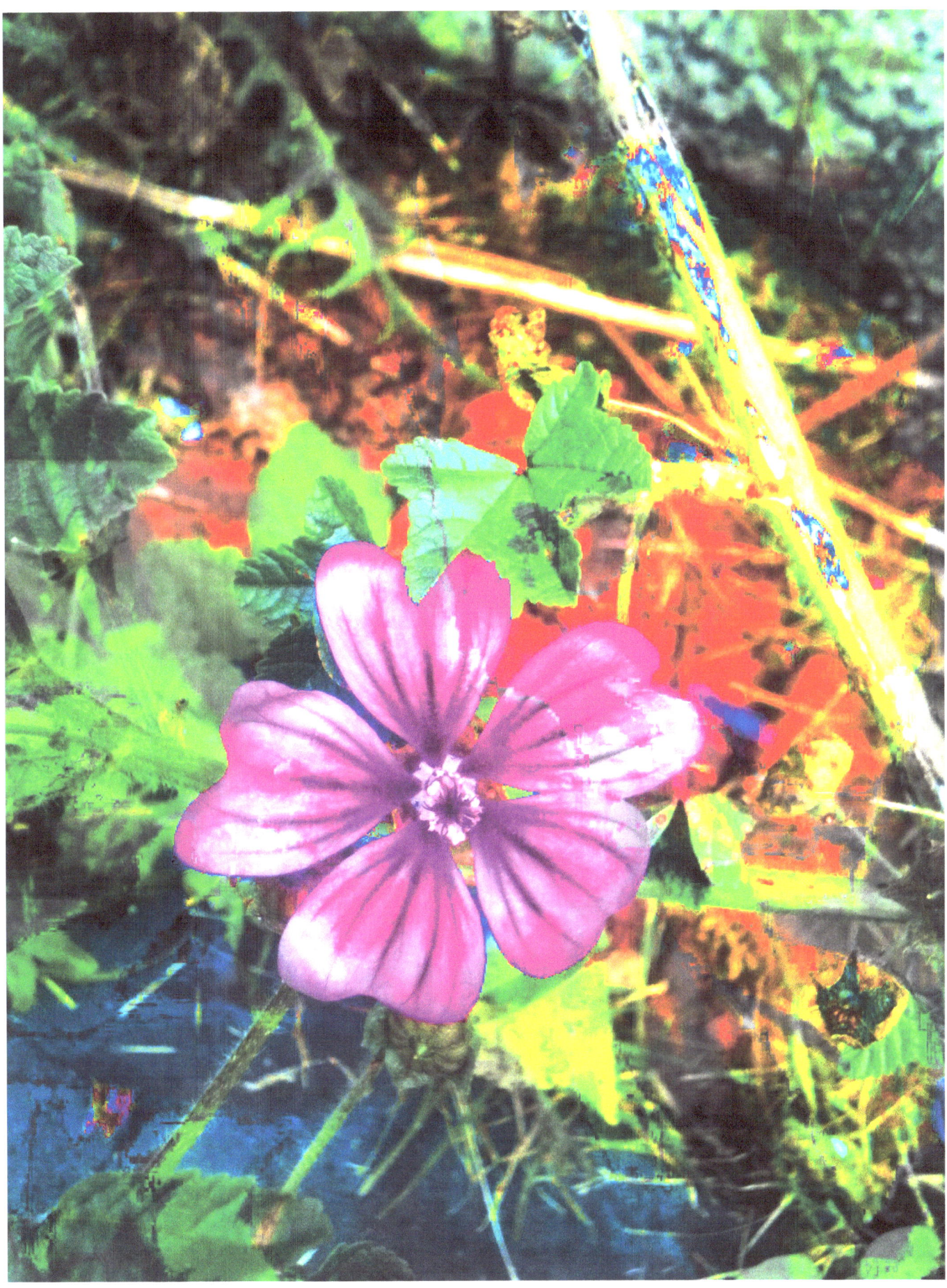

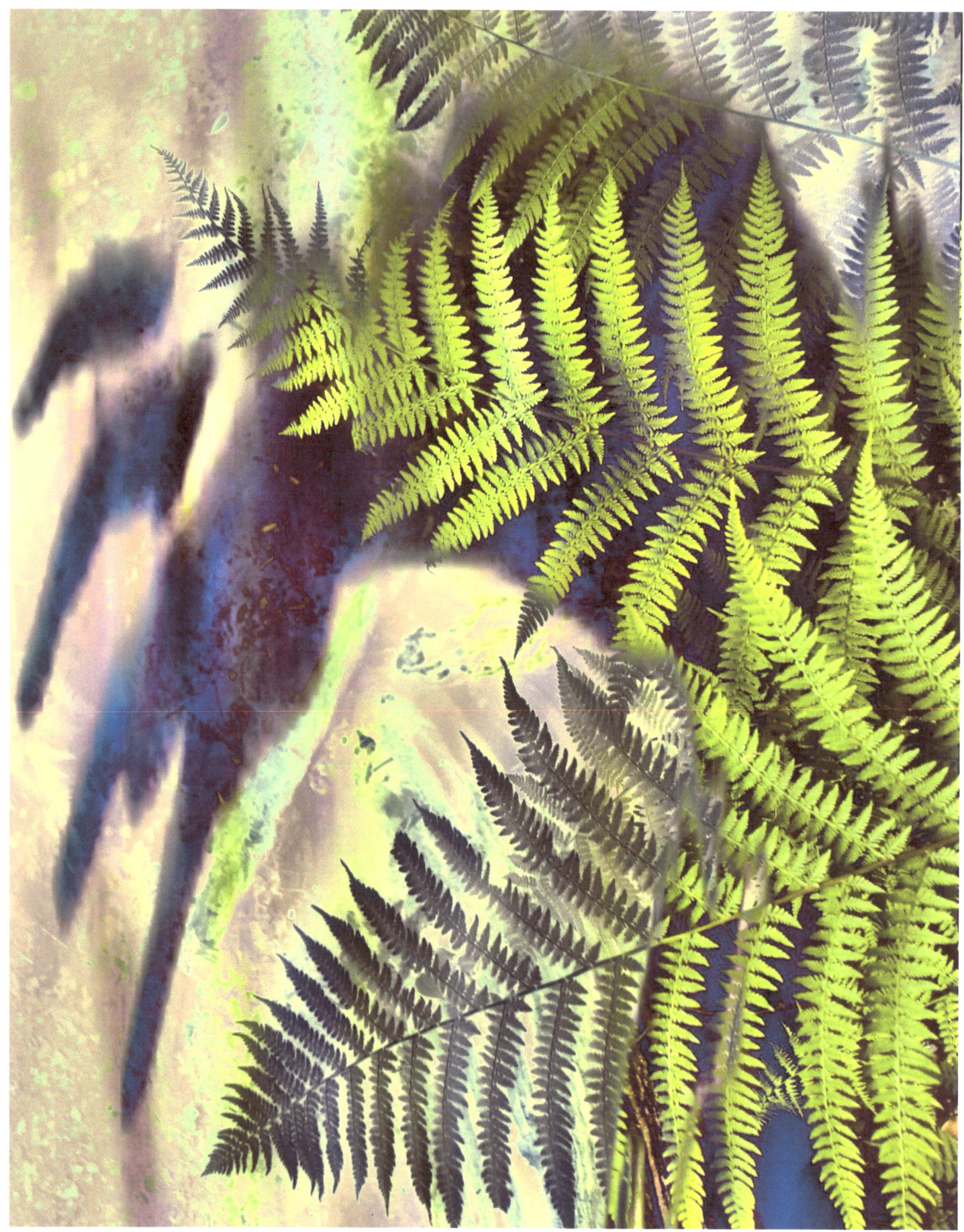

These words are from love in its purest of forms
Written in heart for each one of you all
Your truth is as bright as any candle flame
Any star of the night would bow to your name
For as infinity rivers through the energy flow
Of all and of everything that we see and we know
This infinite creation within your own mind
You are made of the universe, look and then find
A petal of a flower reveals at its base
The central connection that keeps all in place
From its leaves to its roots so the petal is one
With the aroma of the meadow rising with the sun

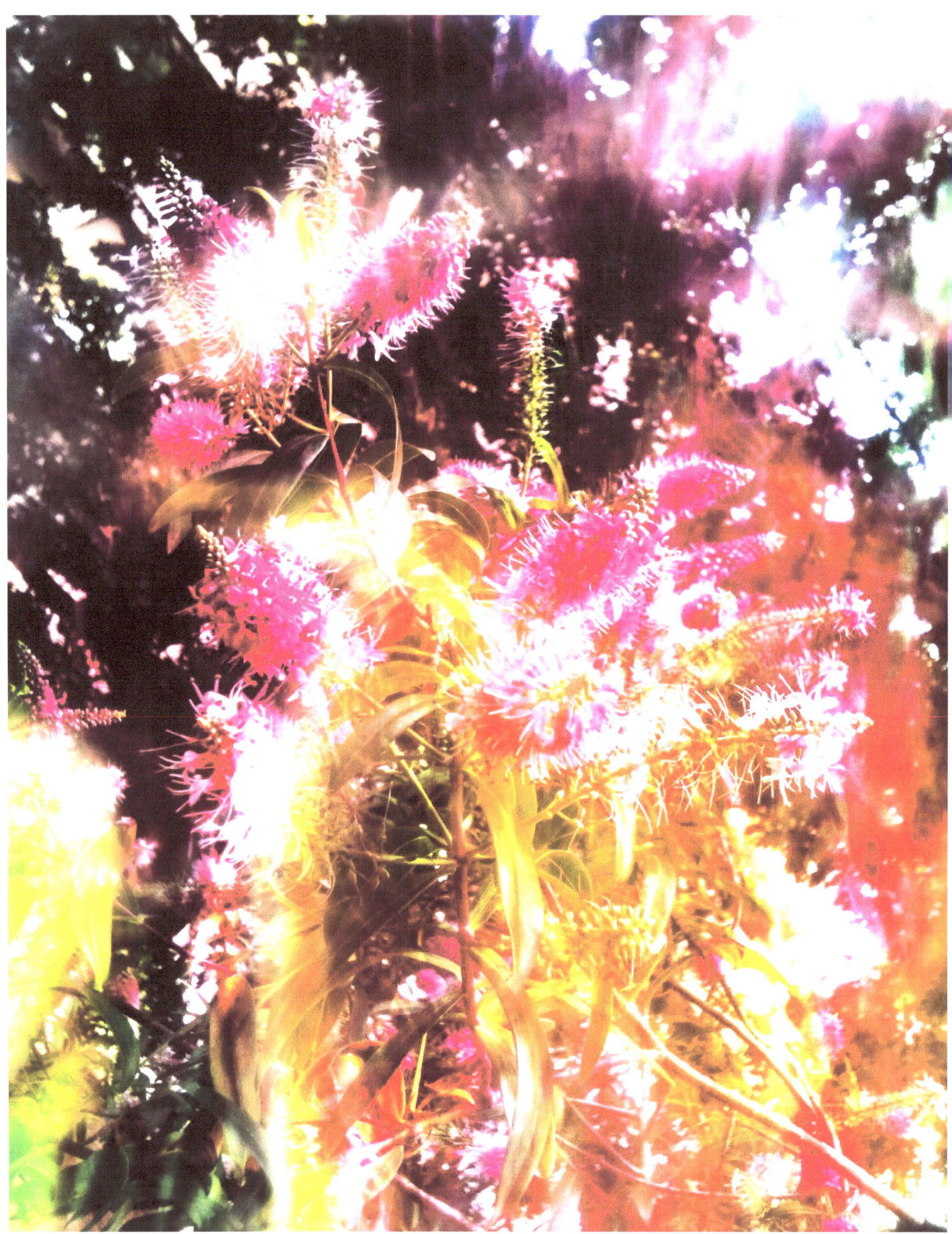

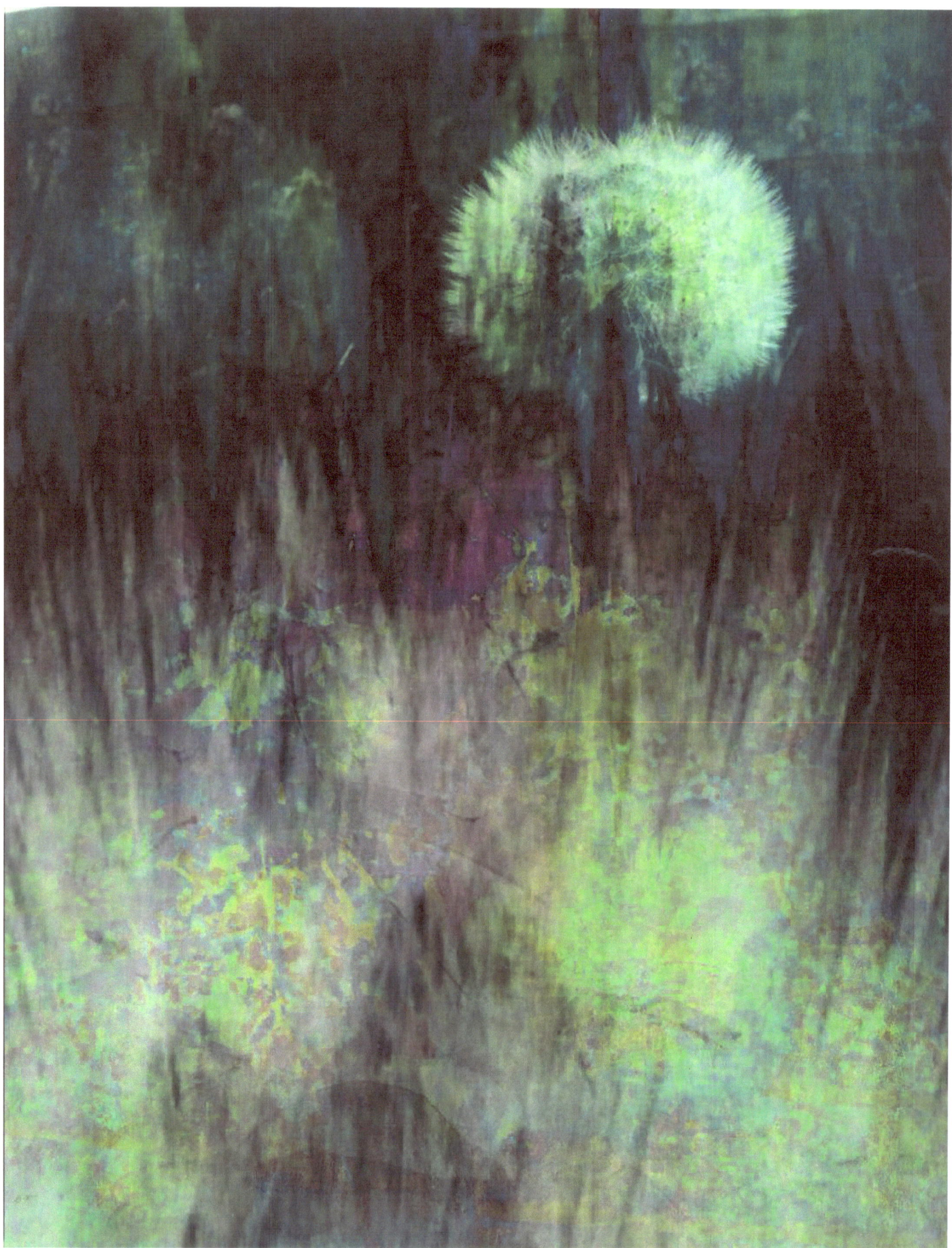

www.ingramcontent.com/pod-product-compliance
Lightning Source LLC
Chambersburg PA
CBHW051108180526
45172CB00002B/819